THANKS FOR PICKING UP MY POOP

ULYSSES PRESS
PO Box 3440
Berkeley, CA 94703
www.ulyssespress.com

ISBN13: 978-1-646043-227-2
Library of Congress Catalog Number: 2015937563

Printed in the United States

10 9 8 7 6 5 4 3 2 1

Acquisitions: Keith Riegert
Managing Editor: Claire Chun
Writer: Molly Upton
Proofreader: Renee Rutledge
Cover and interior design: Jake Flaherty

THANKS FOR PICKING UP MY POOP

Everyday Gratitude from Dogs

PHOTOGRAPHS BY MARK ROGERS

It's just another great day.

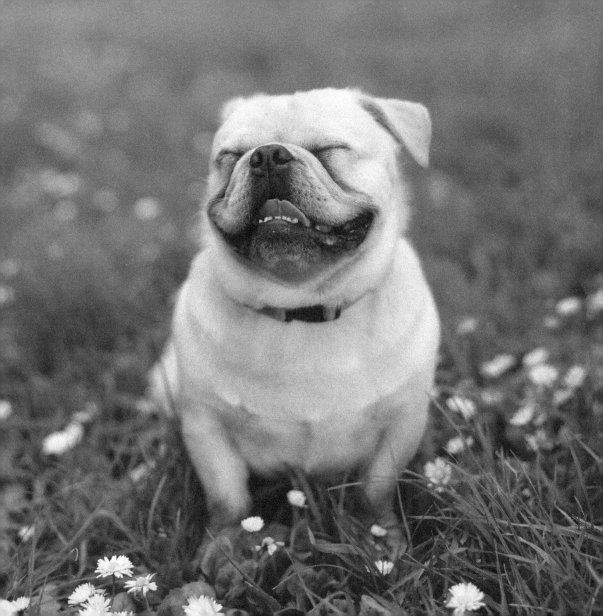

TAKING THE LEAP IS
EASIER WITH YOU THERE
TO CATCH ME.

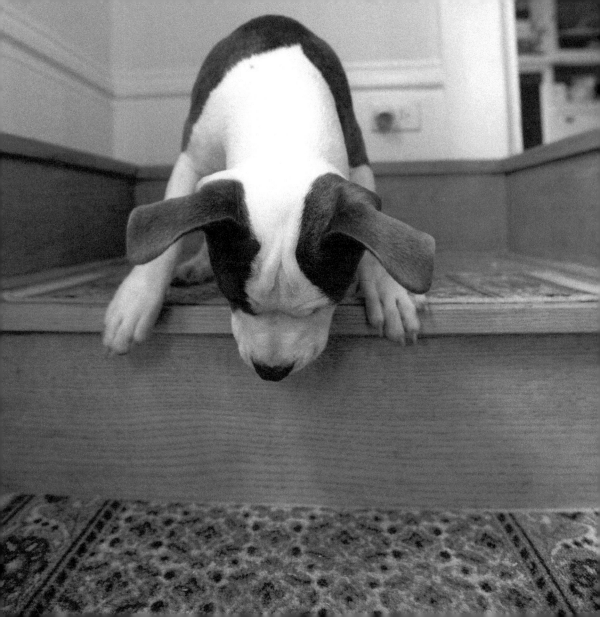

No matter what stands between us, I'll always show you my love.

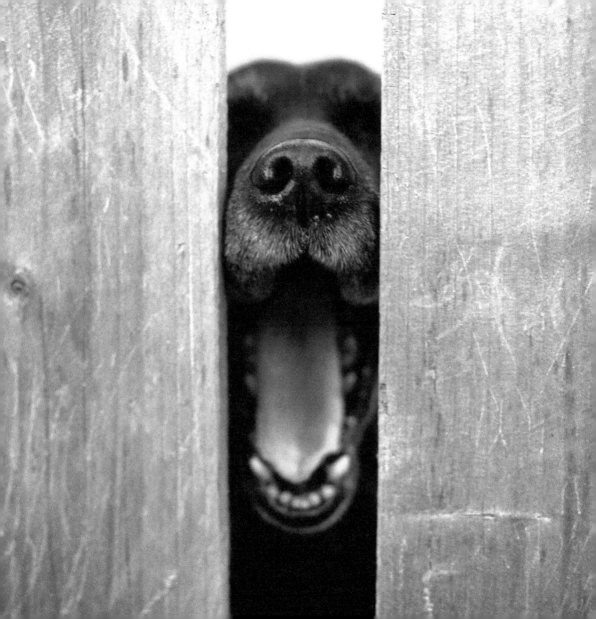

THANKS FOR ALWAYS
HAVING MY BACK.

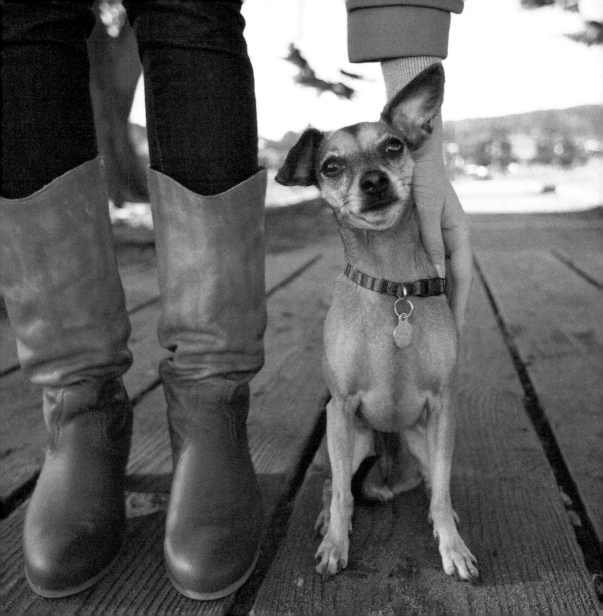

You know we will always
be here to support you.

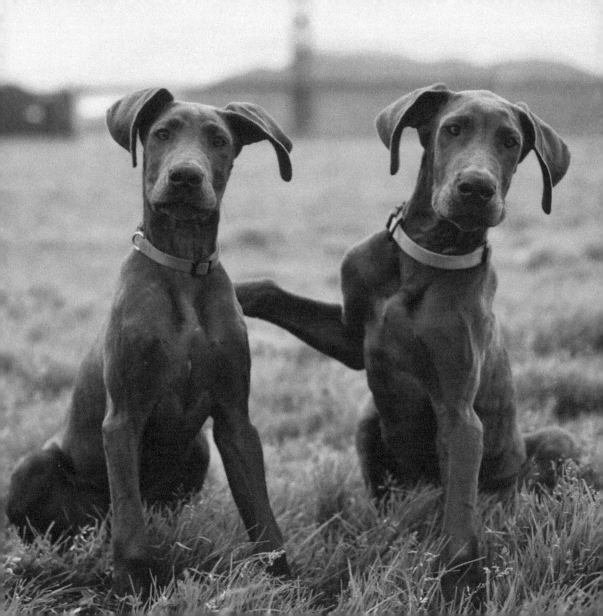

YOU LOOK LIKE YOU
COULD USE A FRIEND.

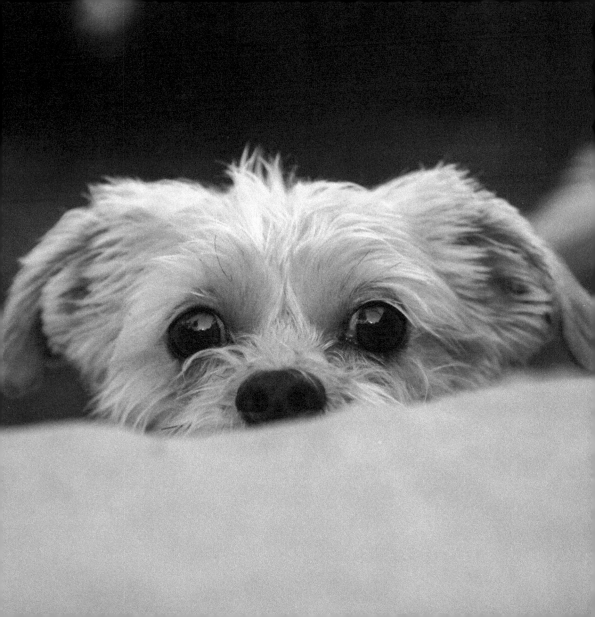

I appreciate you picking up after me on our walks. Today, I will pick up all the food you drop.

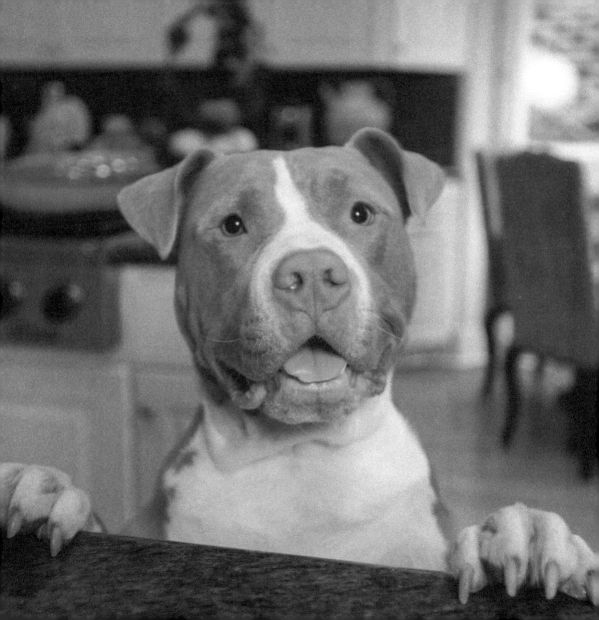

Some-bunny loves you!

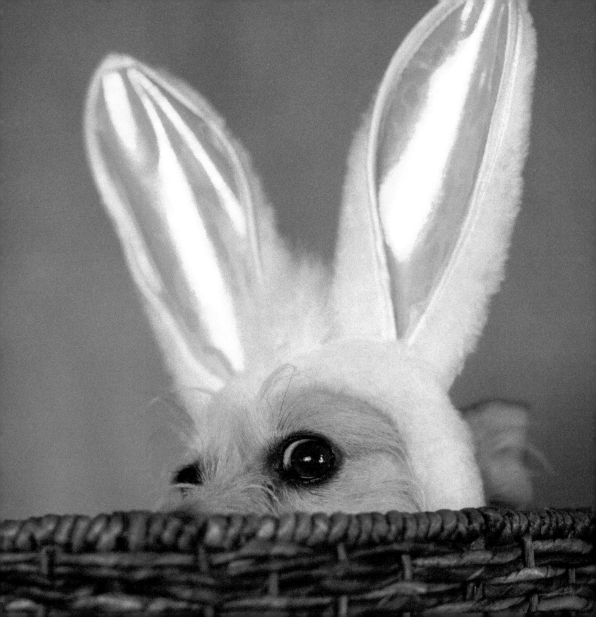

Thanks for always tolerating a second (and third) opinion.

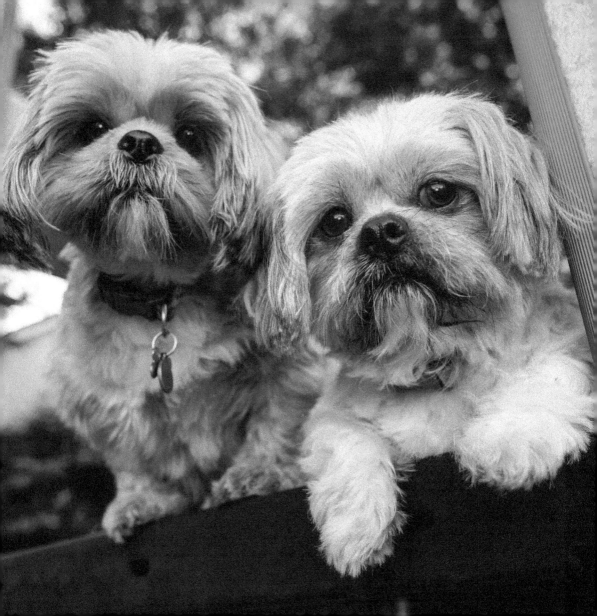

Once in a while, it's nice to look at the world from a whole different angle.

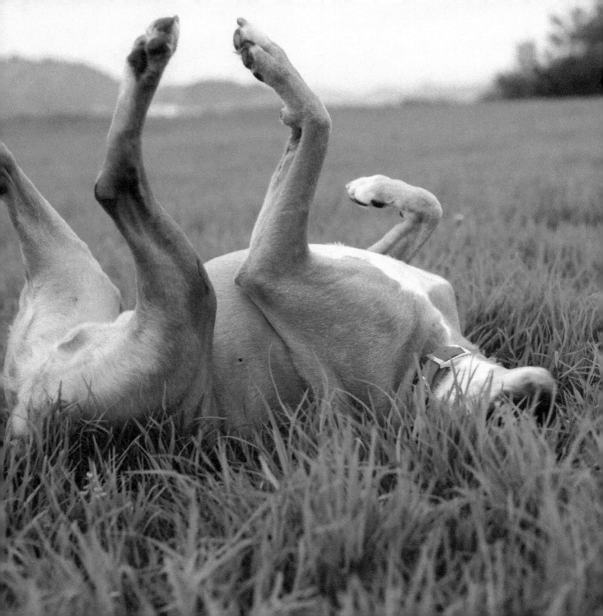

I'M SO LUCKY WE'RE GROWING OLD TOGETHER.

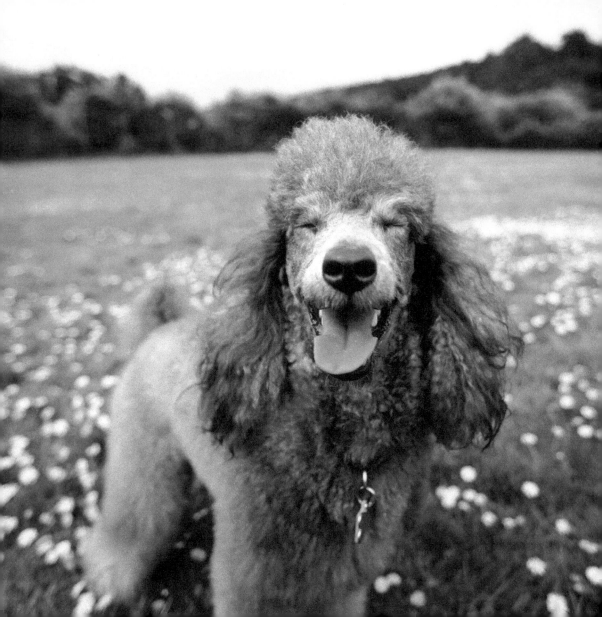

A warm bath cleanses both the mind and body.

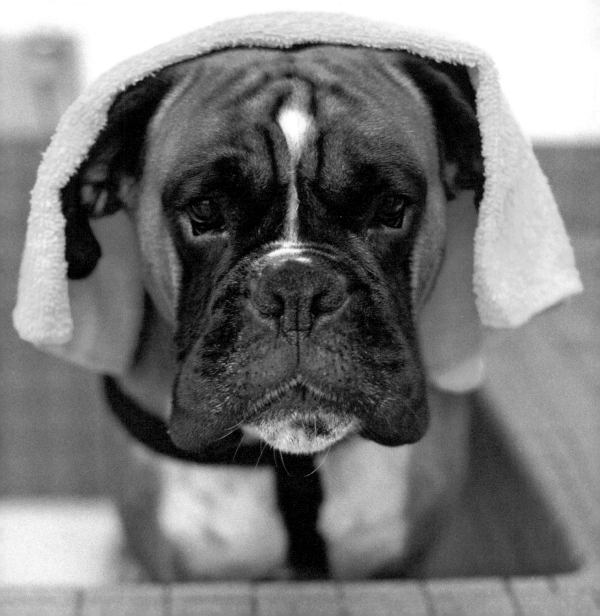

I look forward to
the moments that
bring us together.

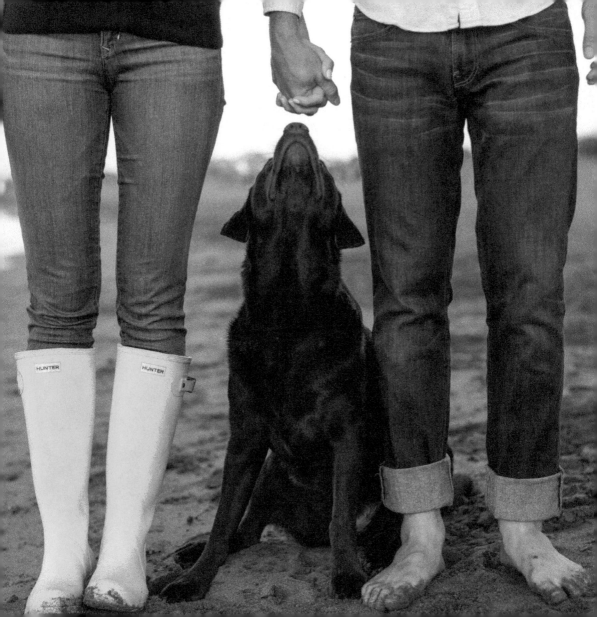

THANKS FOR LETTING ME
SPREAD MY WINGS!

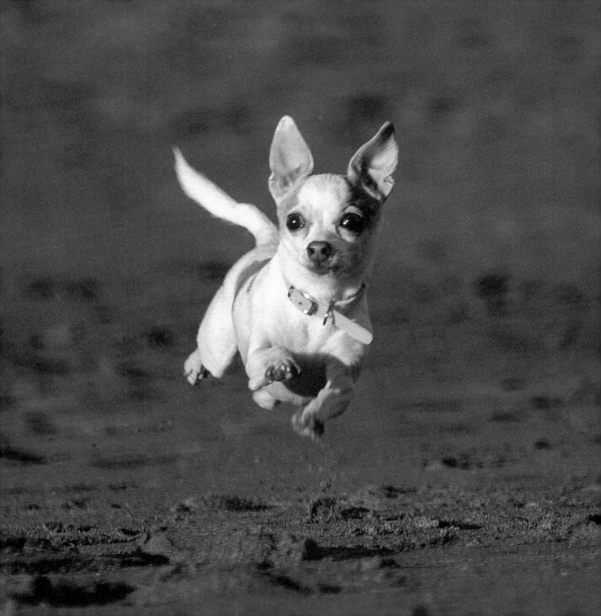

It's embarrassing how much I love you.

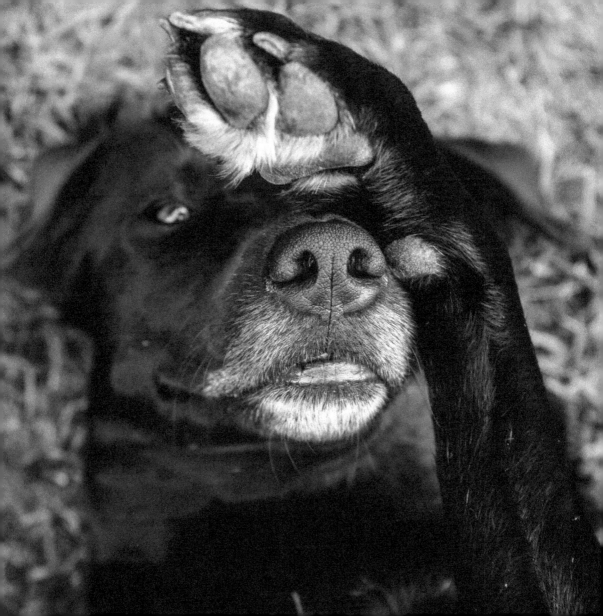

Our walks are always
so educational,
don't you think?

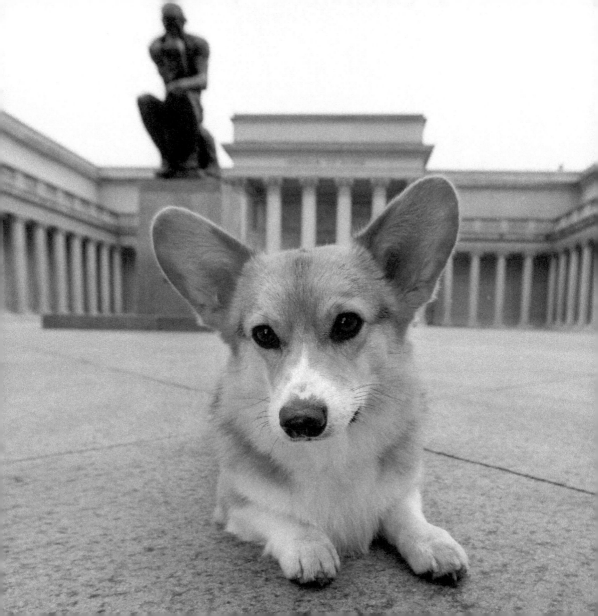

I'M SO EXCITED. GETTING THERE IS THE BEST PART.

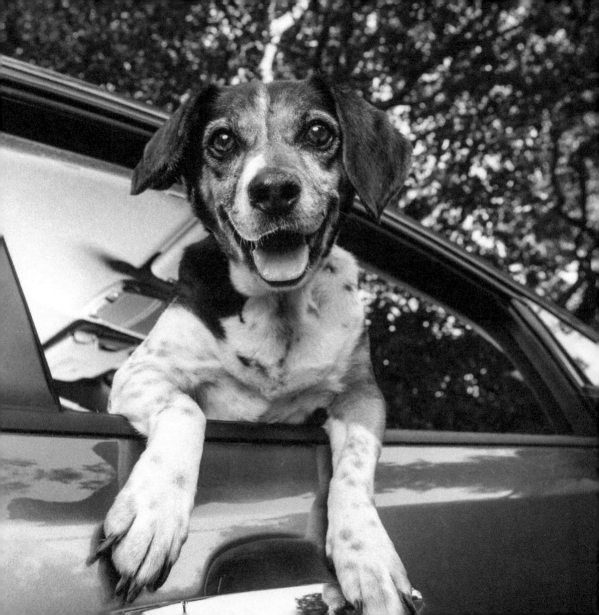

If you know the song,
always feel free to join in.

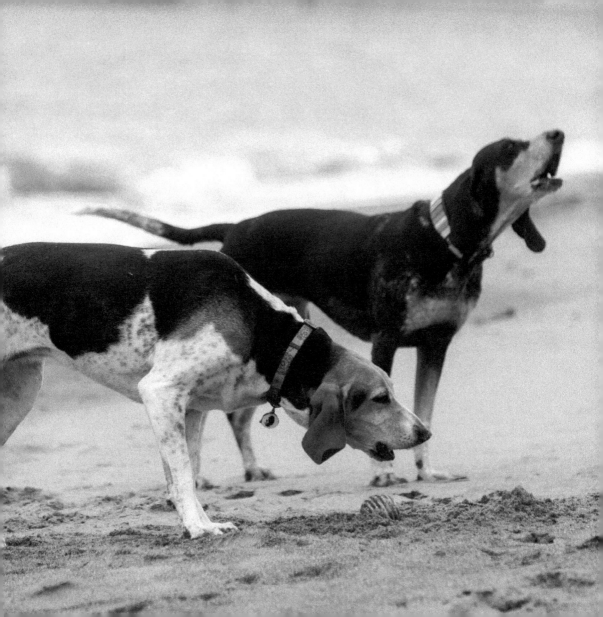

It's after five,
let your tongue down.

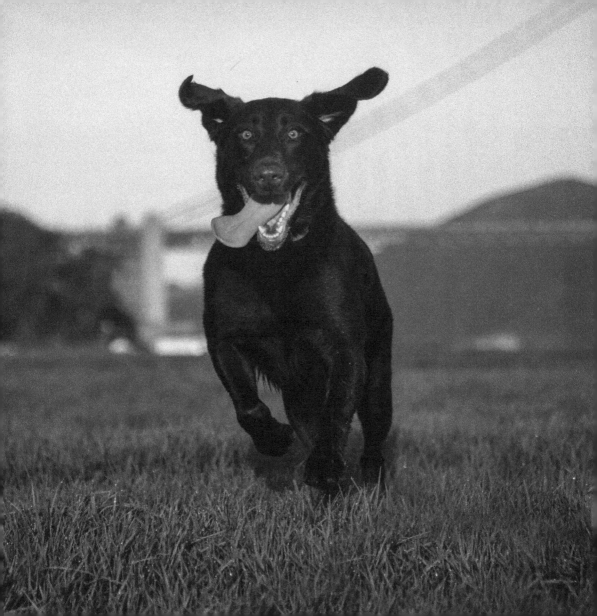

BEAUTY IS IN THE DETAILS—
EVERY BLADE OF GRASS
IS WORTH A LOOK.

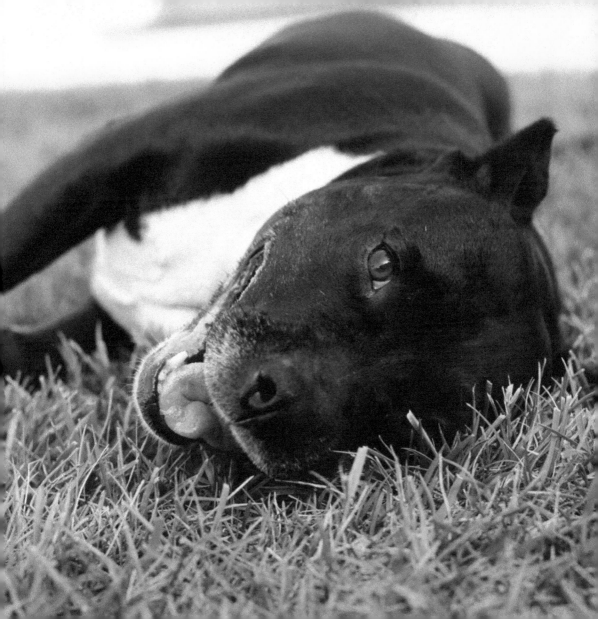

This tennis ball is irreplaceable. Much obliged for its swift return.

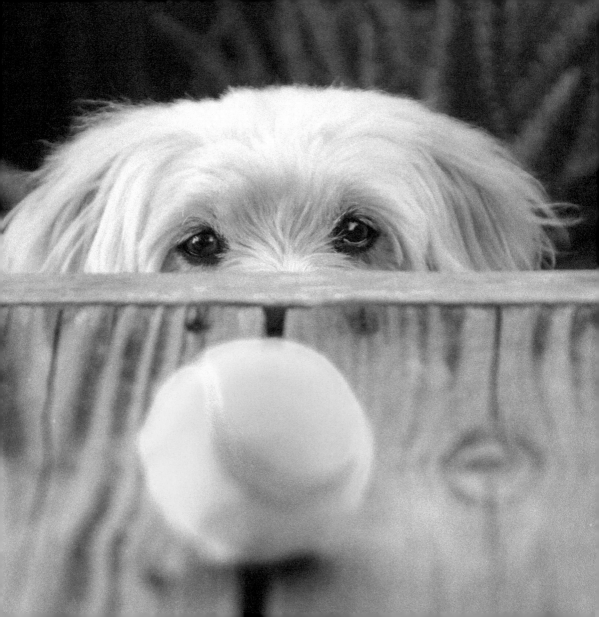

Paws and enjoy the art all around us.

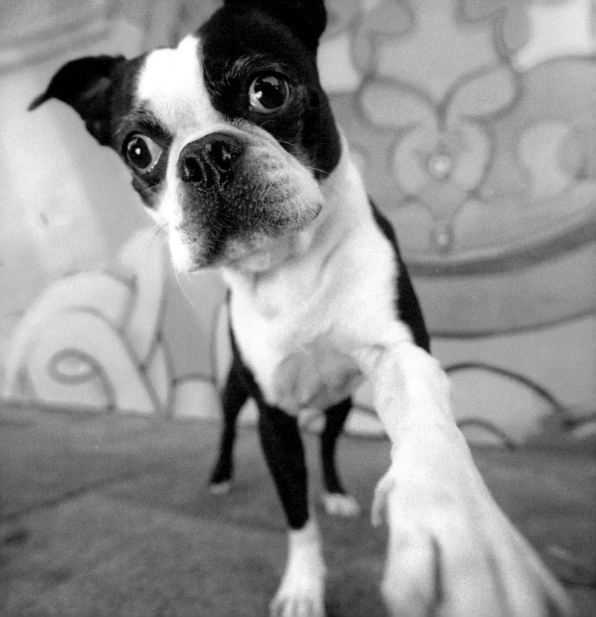

Thanks for being such
a guard human.

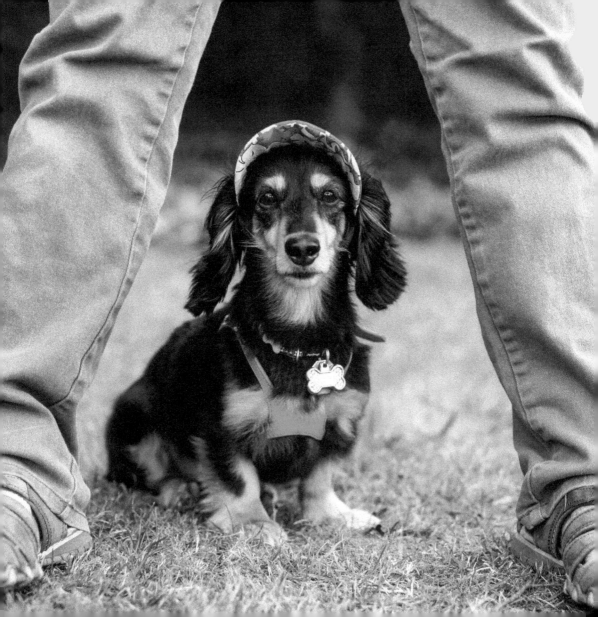

Thanks for all the kisses!

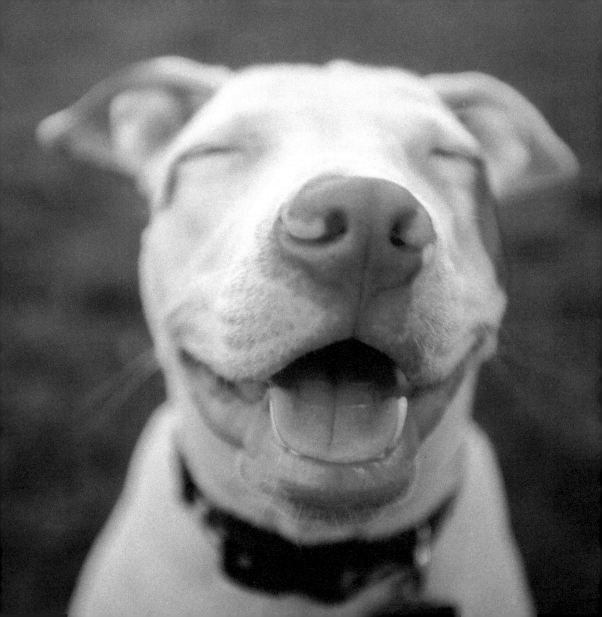

We can always dig our way out, together.

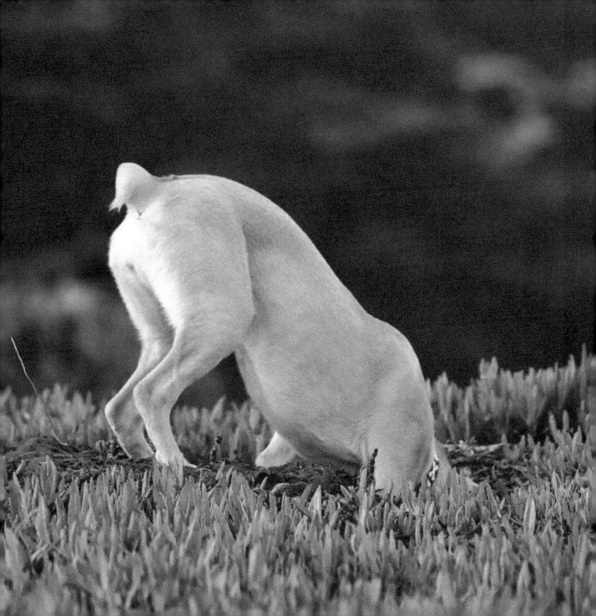

WE'RE HAPPY TO KEEP
THE BED WARM WHILE
YOU'RE AT WORK.

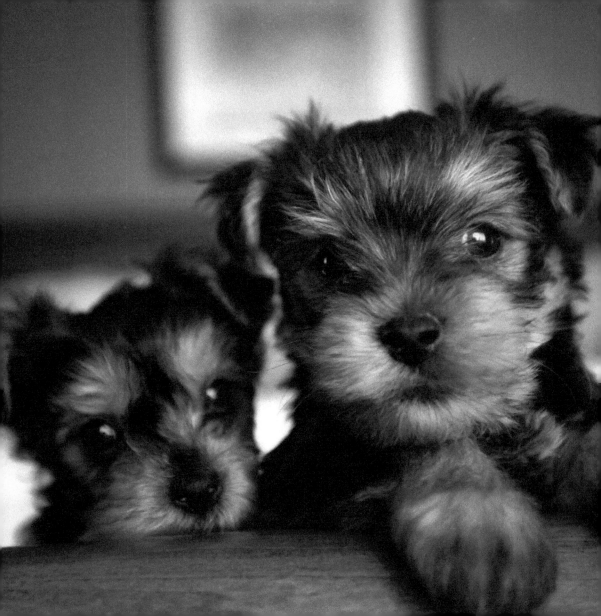

Thanks. I think?

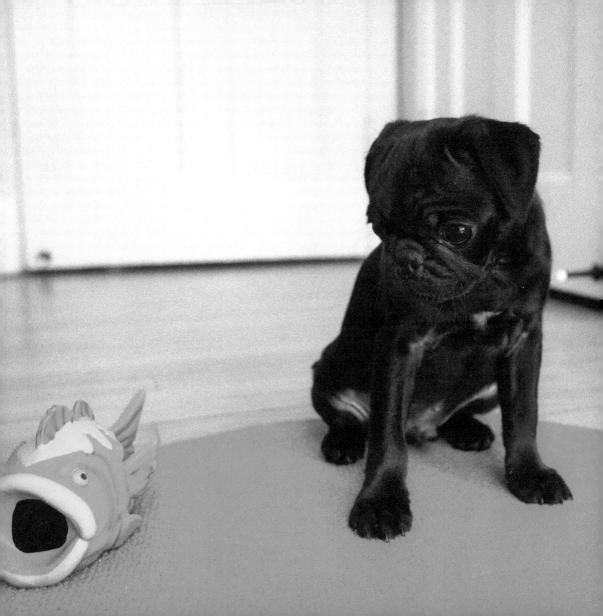

We can never thank you
enough for making our
family a part of your family.

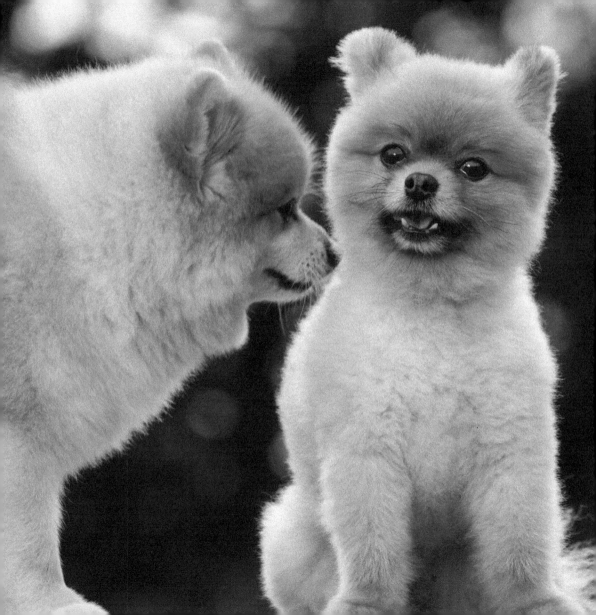

Today is the day you let me drive. I can just feel it.

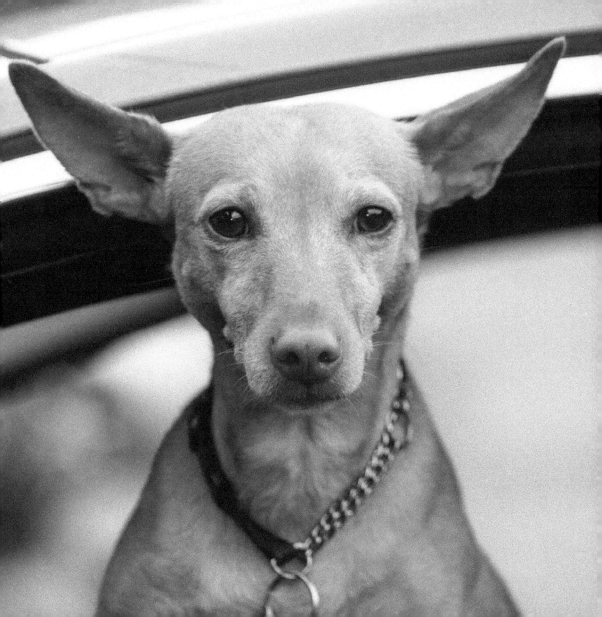

NEVER FORGET HOW MUCH
I LOOK UP TO YOU.

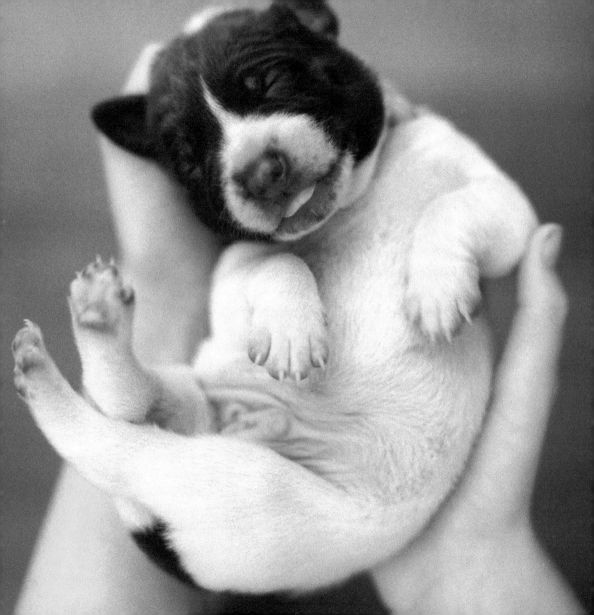

Always treat yourself as well as you treat us (and don't forget the treats).

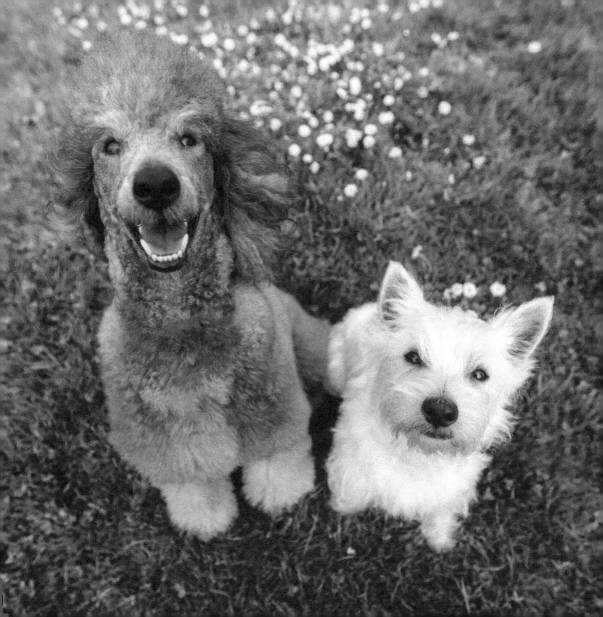

Take this sandy treasure
as a token of our love.

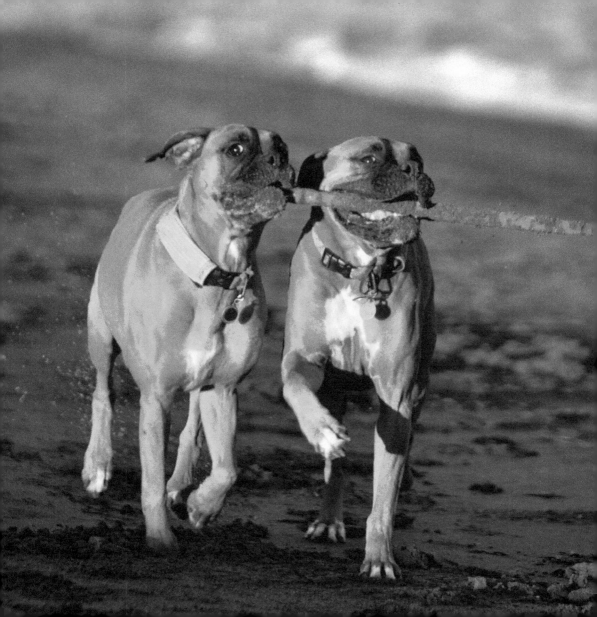

Rest now, fetch later.

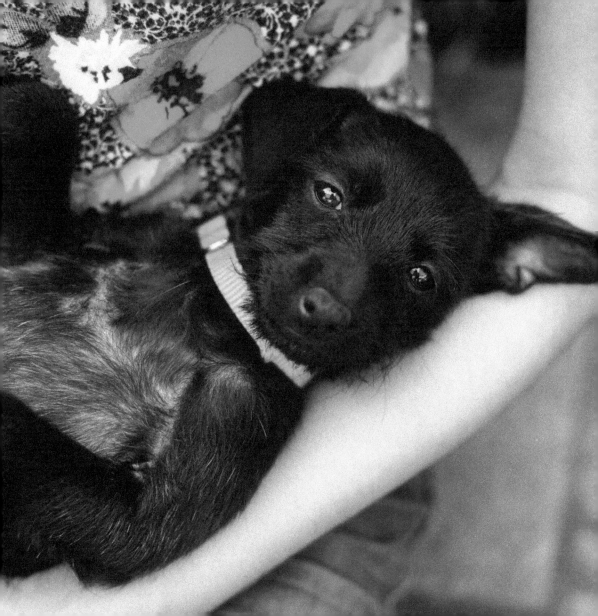

From time to time
everything just feels
like it's the right size.

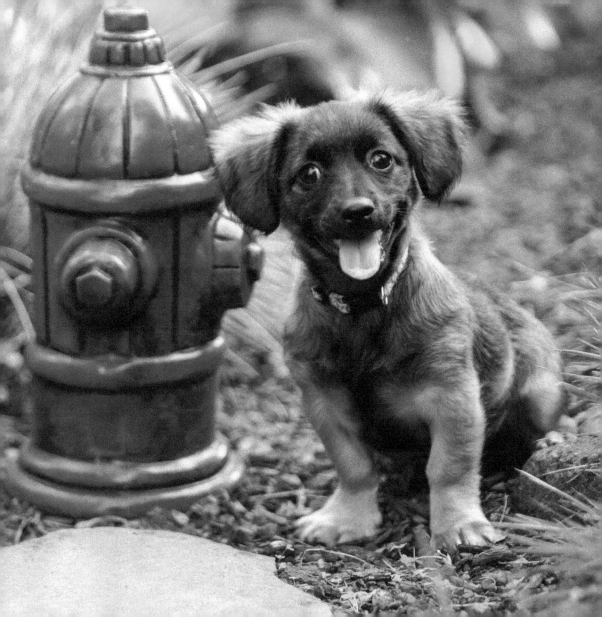

I am so thankful for warm beds, dark shades and our lazy Sunday mornings.

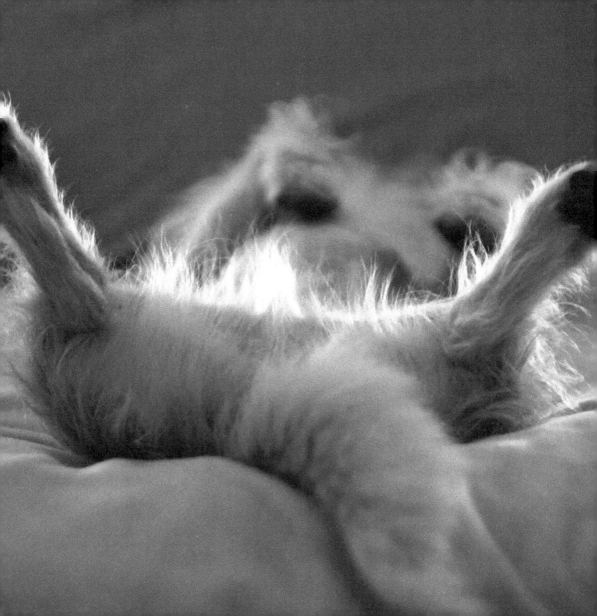

MY EYES ARE CLOSED
TO YOUR FAULTS.

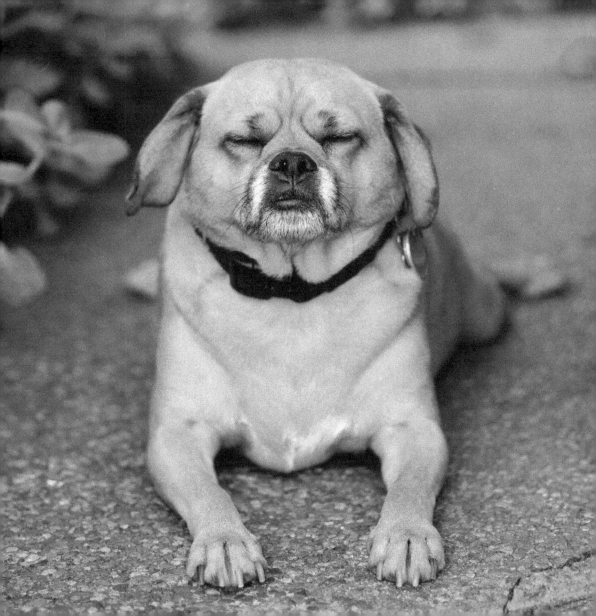

Sailing through life with you is our greatest wish.

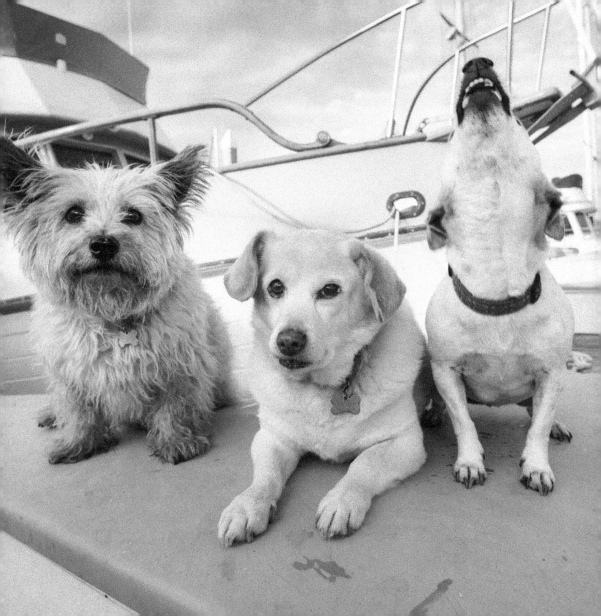

Thank you for saying my favorite word: Dinner.

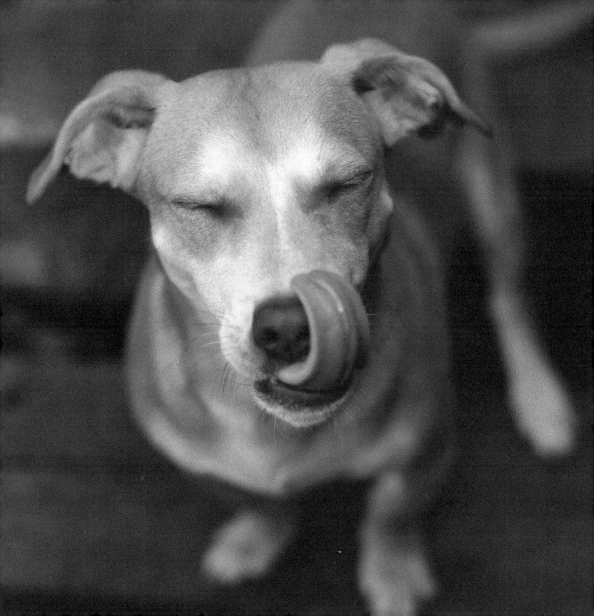

I'll always hang on your every word.

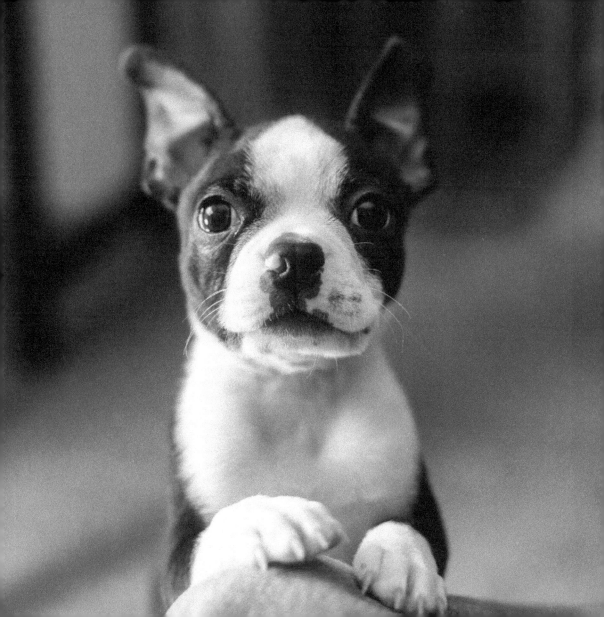

I'M HERE IF THERE'S
ANYTHING YOU NEED.

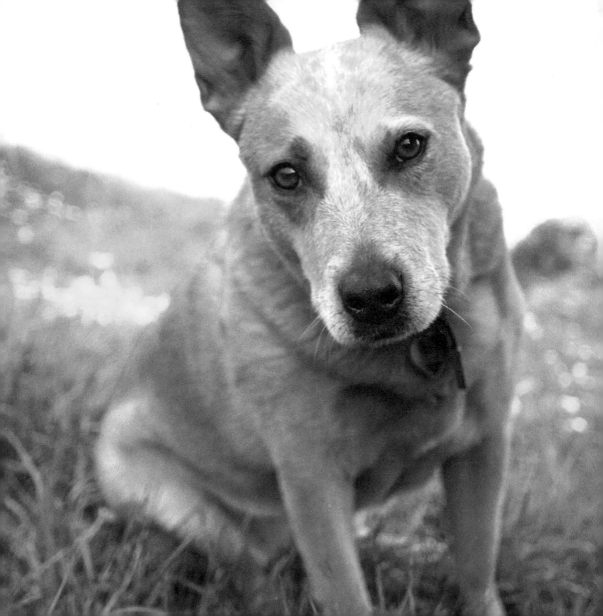

Next time you poop out on our walk, I'll carry you. I promise.

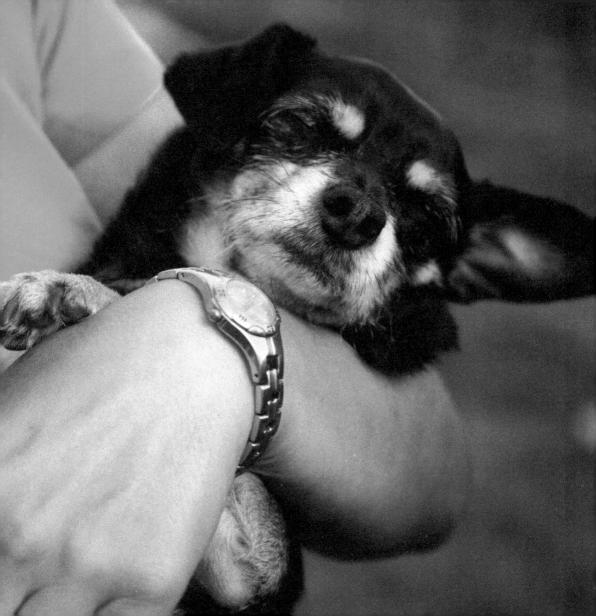

A warm house, a soft rug and a good chew. What more could a dog wish for?

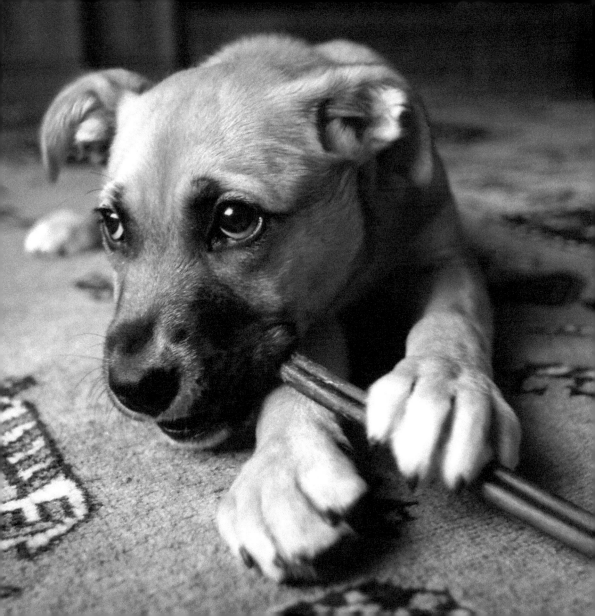

You're worth the effort.

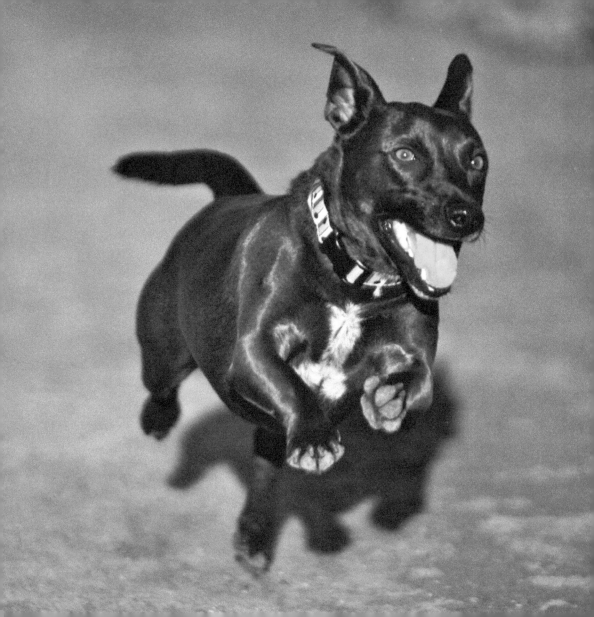

TODAY IS GOING TO
BE AMAZING.

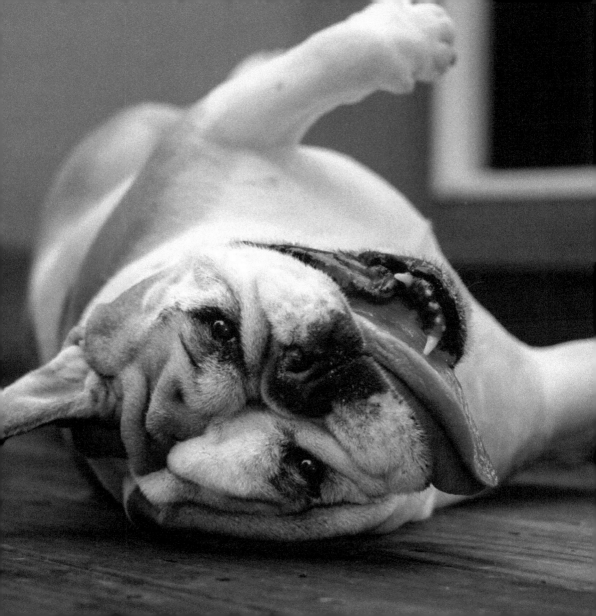

I can always count on you to be at the other end of the rope.

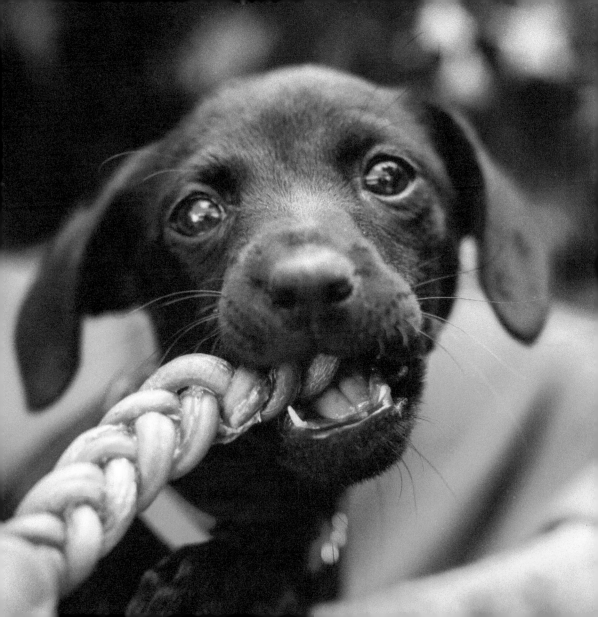

Life doesn't get any
better than this.

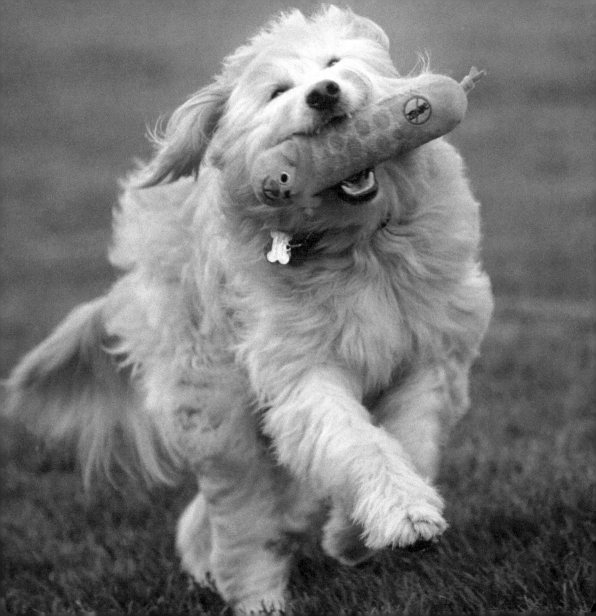

About the Photographer

Mark Rogers is a San Francisco-based pet photographer with an uncanny ability to draw out the personalities and emotions of his animal and human subjects. His eye-catching, often humorous images of dogs, cats and other critters appear regularly in national advertising campaigns and print publications.

Repeatedly chosen as one of the Bay Area's best pet photographers, Mark is also highly sought by private clients to work with their pets and donates much of his time to animal welfare and rescue groups.

Mark lives with his wife, Anne, his dog, Bizzy, and their cat, the mischievous Jimmy Chew.

To see more recent work you can visit his website at markrogersphotography.com as well as Facebook and Instagram. Mark is represented by Freda Scott.